Green County Barn Quilt Coloring Book
John H. Lettau

Wisconsin Dairyland Barn Quilts

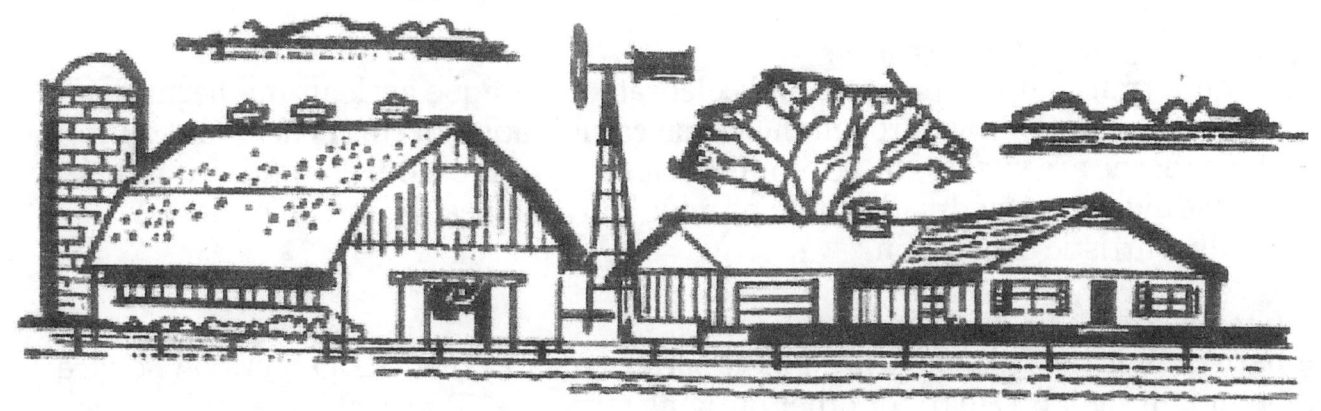

Cover Barn Quilts

Dutchman's Puzzle Union Star
Spinning Star Windmill Star

Coloring for All Ages

ENJOY – RELAX - HAVE FUN - BE CREATIVE

2016 Copyright John H. Lettau

Green County Wisconsin Barn Quilt Project

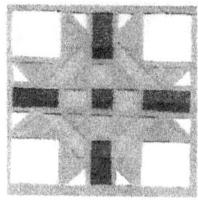 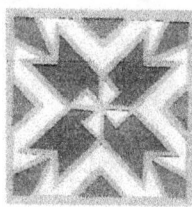

A drive through the rural farmland of Green County Wisconsin is very colorful today because many brilliant "quilt blocks," called barn quilts, are on display on barns throughout the area. Five sample barns quilt patterns located in the county are pictured above...Belted Star, Marine Star, Sunshine in the Valley, Dutchman's Puzzle and Churn Dash.

Objectives of Barn Quilt Projects
Barn quilt trails help to promote and celebrate the unique agricultural heritage and history of Green County through the visual combination of rural barns and quilt pattens. Barns are vital to the economic well being of the rural community and surrounding area. Handmade quilts provide warmth, beauty and an outlet for individual artistic expression.

What is a Barn Quilt?
A barn quilt is made by painting a quilt pattern on a ¾ inch MDO plywood Square then mounting it on a barn or other outlying structure. Two coats of primer are applied to both sides of the board and edges. After the pattern is drawn out painter's (Frog) tape is applied outlining the various sections of the quilt pattern. Three coats or more of each color are applied, with each coat being allowed to dry thoroughly. After the quilt is finished, it is allowed to cure for at least two weeks before it is mounted.

Making a barn quilt allows individuals and volunteer groups the opportunity to create and paint their own quilt square. The design that is chosen may represent a family pattern from a loved quilt or perhaps a new pattern meaningful to the individual creator(s).

Objectives of Tennessee Barn Quilt Projects
1. To reflect the agricultural heritage of the area
2. To be visible from the road
3. To bring pride to the area
4. To promote tourism in the region

Individual & Group Objectives
5. To sharpen math and drafting skills
6. To promote creativity on a personal level
7. To provide projects for 4H & FFA clubs
8. To help promote towns and cities

Green County Barn Quilt Information

Barn Quilts of Green County Wisconsin

Flying Star	County Rd S	Monroe, Wisconsin
Hens 'n Chicks	County Rd K	Monroe, Wisconsin
Farm Angel	Hwy 69	Monticello, Wisconsin
King's Crown	Stateline Rd	Brodhead, Wisconsin
Windmill Star	Blumer Rd	Monroe, Wisconsin
Four Stars	Prairie Rd	Brodhead, Wisconsin
FFA Rising Star	Greenbush Rd	Brodhead, Wisconsin
Turkey Tracks	Biggs Rd	Argyle, Wisconsin
Saw Tooth Star	Hwy 69 S	Monroe, Wisconsin
North Star	Race Rd	Brodhead, Wisconsin
Peaceful Hours	River Rd	Monticello, Wisconsin
Water Wheel	County Rd H	New Glarus, Wisconsin
Constellation Block	County Rd P	Monroe, Wisconsin
Queen's Jewels	North McDermott Rd	Albany, Wisconsin
Tumble Weed	Hwy 11	Monroe, Wisconsin
Variable Star	Hwy 11	Monroe, Wisconsin
Dove At My Door	County Rd Y	Monroe, Wisconsin
LeMoyne	Hwy 69	Monticello, Wisconsin
Churn Dash	Sandy Hook Rd	Brooklyn, Wisconsin
Flying Frontier	County Rd OK	Brodhead, Wisconsin
Valley Star	Doughtery Creek Rd	Argyle, Wisconsin
Dutchman's Puzzle	Franklin Rd	Monroe, Wisconsin
Flies In The Barn	Franklin Rd	Monroe, Wisconsin
Mom's Den	Grossen Rd	Monticello, Wisconsin
Sunshine In The Valley	County Rd SS	Monroe, Wisconsin
Spinning Star	County Rd M	Browntown, Wisconsin
Belted Star	Brunkow Rd	Juda, Wisconsin
Pole Star	Smock Valley Rd	Browntown, Wisconsin
Star Puzzle	Hwy 69	Monroe, Wisconsin
Marine Star	Spring Creek Rd	Brodhead, Wisconsin
Kayak	Bethel Rd	Monroe, Wisconsin
Little Giant	County Rd EE	Monticello, Wisconsin
Interwoven	County Rd K	Juda, Wisconsin
Swiss Star	Cold Springs Rd	Monroe, Wisconsin
Centennial	Joy-Del Rd	Monroe, Wisconsin
Wisconsin	Bethel Rd	Monroe, Wisconsin
Constellation	Stateline Rd	Brodhead, Wisconsin
Cornucopia	Ridge Rd	Argyle, Wisconsin
Comets	County Rd J	Monroe, Wisconsin
Corn & Beans	Decatur/Sylvester Rd	Monroe, Wisconsin
Blazing Star	County Rd KS	Juda, Wisconsin
Hole In The Barn Door	County Rd G	Brodhead, Wisconsin
Grandpa's Delight	County Rd C	Monticello, Wisconsin
Rolling Star	Shanghai Rd	Juda, Wisconsin
Union Star	Yankee Hollow Rd	Blanchardville, Wisconsin
Star Spin	County Rd H	New Glarus, Wisconsin
Dividing Ridge Star	Dividing Ridge Rd	Monticello, Wisconsin
Grandmother's Pride	Brunkow Rd	Juda, Wisconsin
Farmer's Daughter	Five Corners Rd	Monroe, Wisconsin
Evergreen	Middle Juda Rd	Juda, Wisconsin

Barn Quilt Flying Star
Green County Wisconsin Barn Quilts

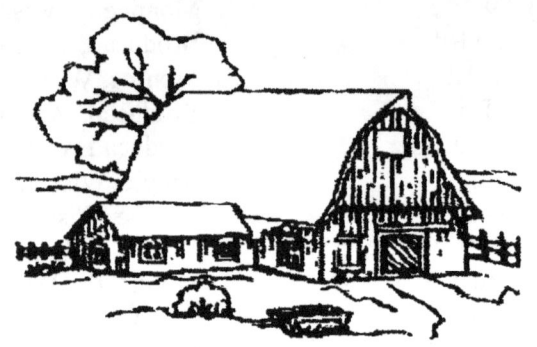

Barn Location
County Road S
Monroe, Wisconsin

Green County Barn Quilt Flying Star

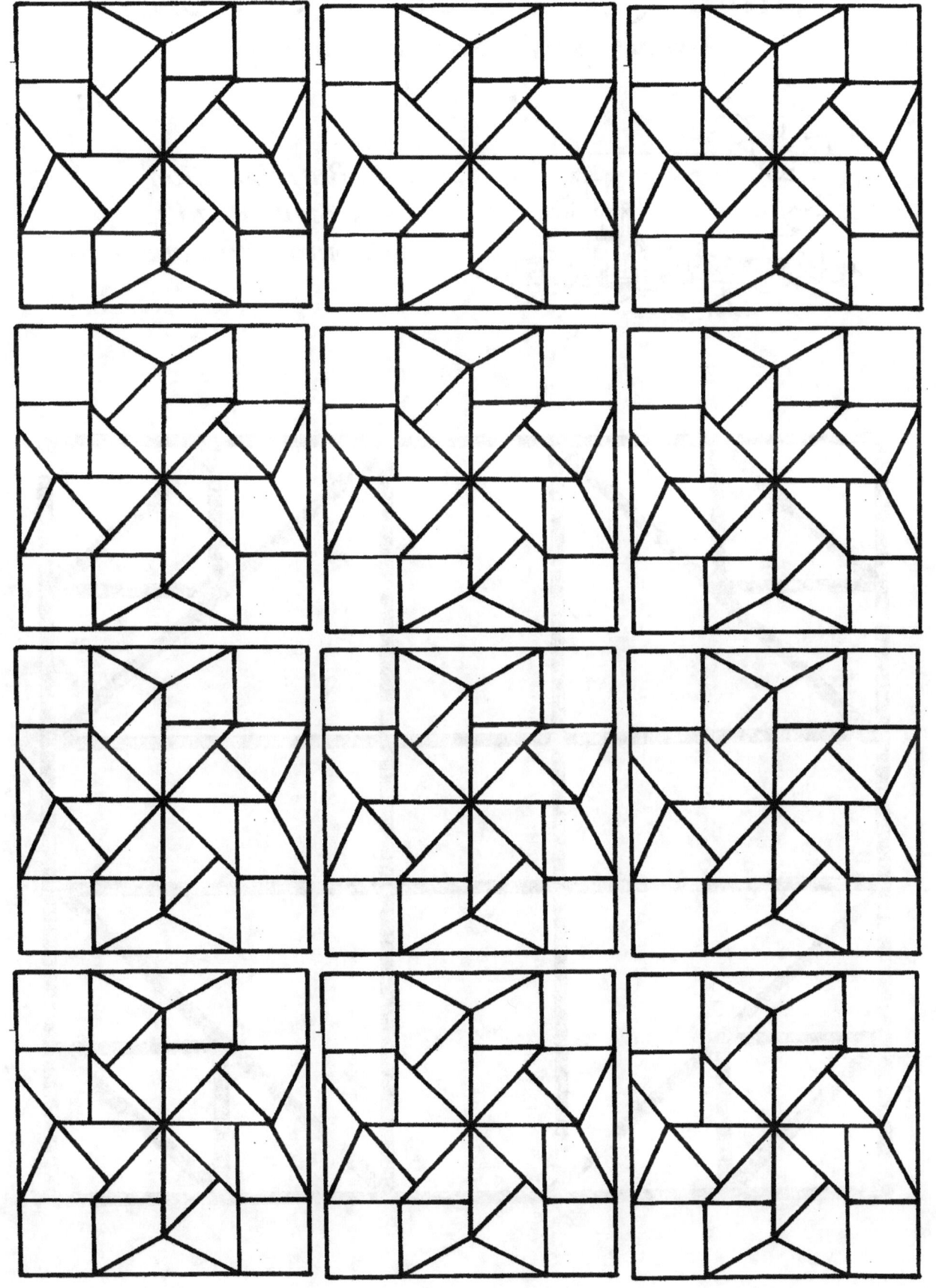

Barn Quilt Hen 'n Chicks
Green County Wisconsin Barn Quilts

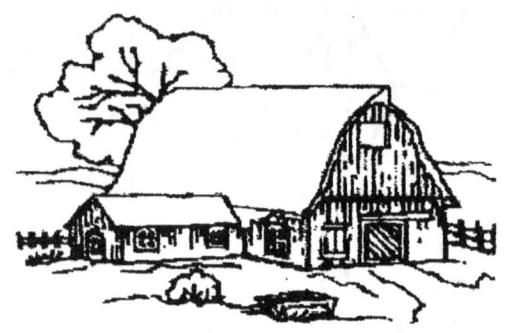

Barn Location
County Road K
Monroe, Wisconsin

Green County Barn Quilt Hens 'n Chicks

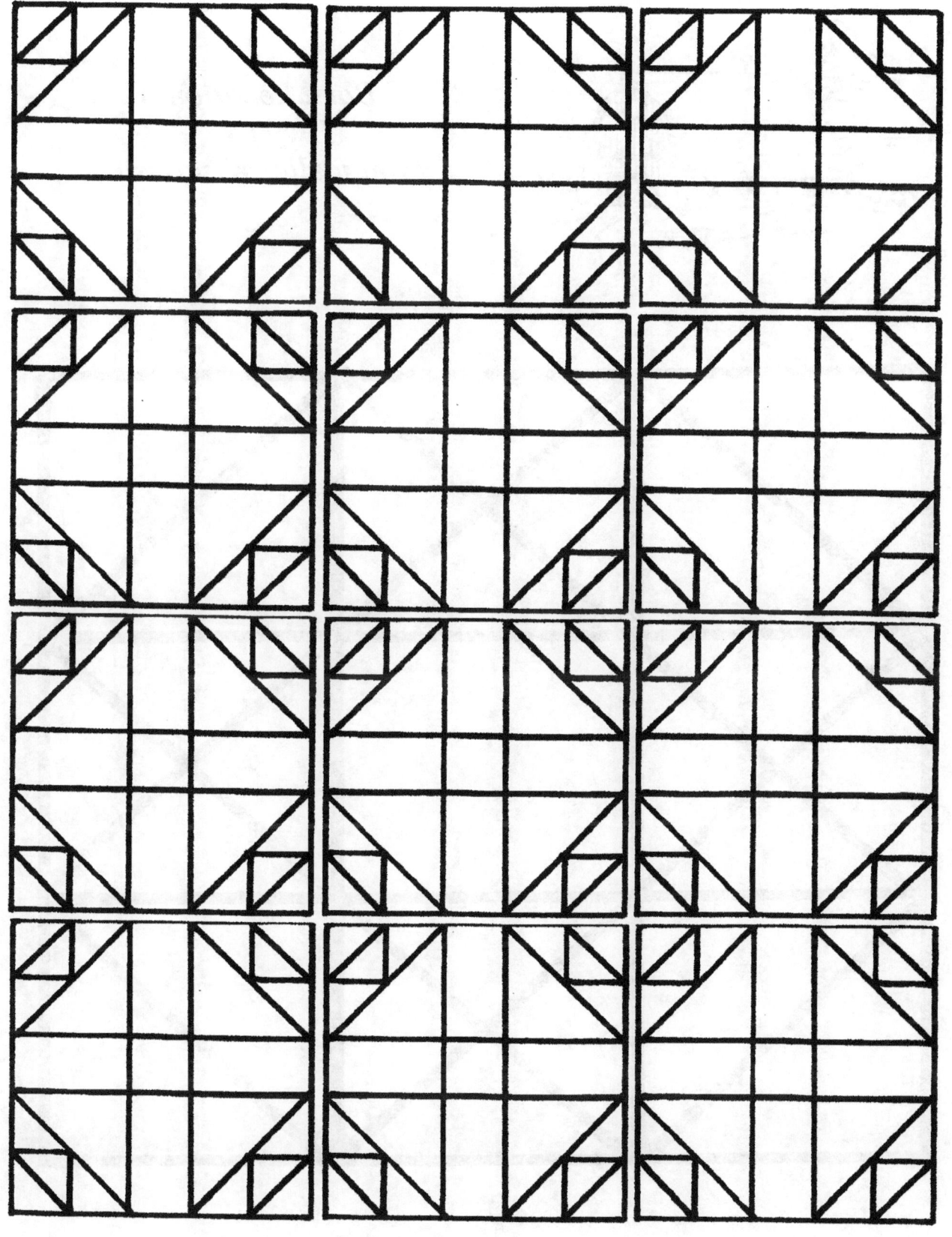

Barn Quilt Farm Angel
Green County Wisconsin Barn Quilts

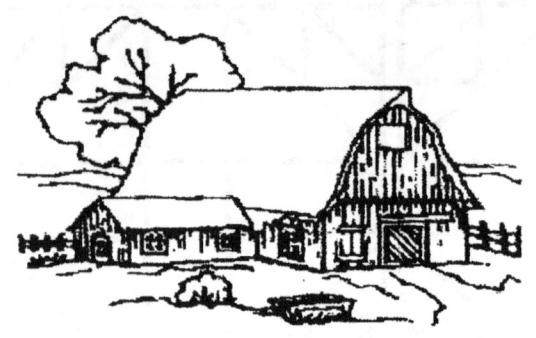

Barn Location
Hwy 69
Monticello, Wisconsin

Green County Barn Quilt Farm Angel

Barn Quilt King's Crown
Green County Wisconsin Barn Quilts

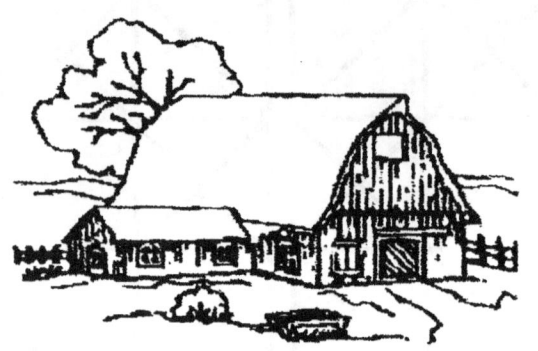

Barn Location
Stateline Road
Brodhead, Wisconsin

Green County Barn Quilt King's Crown

Barn Quilt Windmill Star
Green County Wisconsin Barn Quilts

*Barn Location
Blumer Road
Monroe, Wisconsin*

Green County Barn Quilt Windmill Star

Barn Quilt Four Stars
Green County Wisconsin Barn Quilts

Barn Location
Prairie Road
Brodhead, Wisconsin

Green County Barn Quilt Four Stars

Barn Quilt FFA Rising Star
Green County Wisconsin Barn Quilts

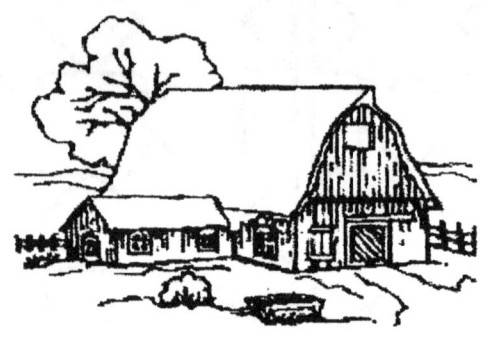

*Barn Location
Greenbush Road
Brodhead, Wisconsin*

Green County Barn Quilt FFA Rising Star

Barn Quilt Turkey Tracks
Green County Wisconsin Barn Quilts

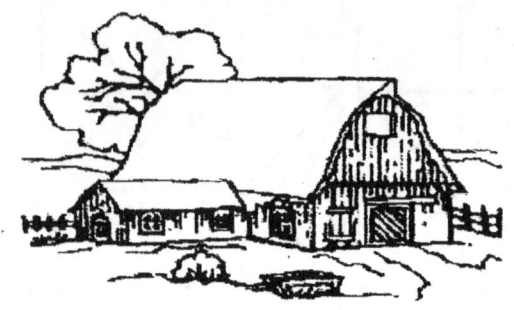

Barn Location
Biggs Road
Argyle, Wisconsin

Green County Barn Quilt Turkey Tracks

Barn Quilt Saw Tooth Star
Green County Wisconsin Barn Quilts

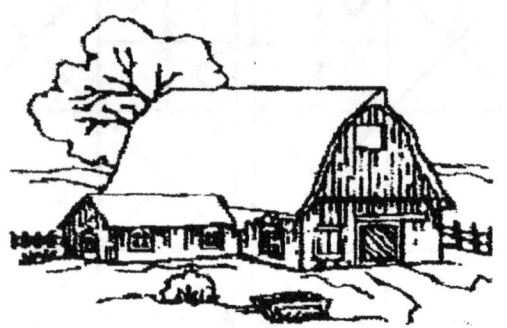

Barn Quilt Location
Hwy 69 S
Monroe, Wisconsin

Green County Barn Quilt Saw Tooth Star

Barn Quilt North Star
Green County Wisconsin Barn Quilts

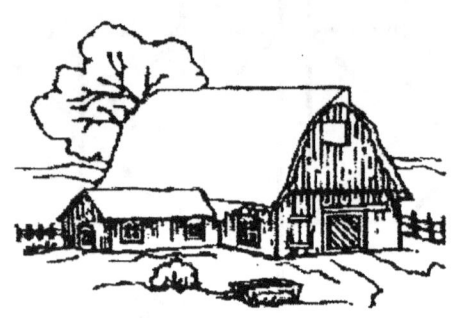

Barn Location
Race Road
Brodhead , Wisconsin

Green County Barn Quilt North Star

Barn Quilt Peaceful Hours
Green County Wisconsin Barn Quilts

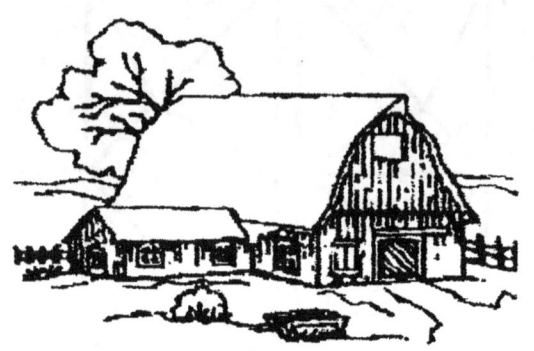

Barn Location
River Road
Monticello, Wisconsin

Green County Barn Quilt Peaceful Hours

Barn Quilt Water Wheel
Green County Wisconsin Barn Quilts

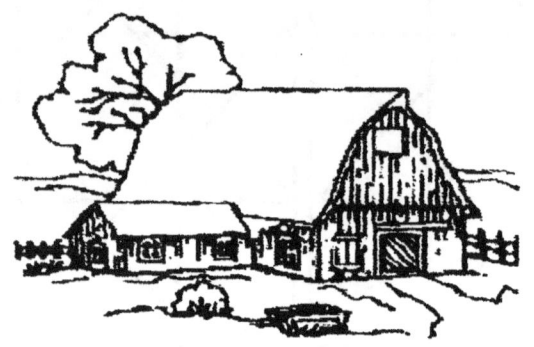

Barn Location
County Road H
New Glarus, Wisconsin

Green County Barn Quilt Water Wheel

Barn Quilt Constellation Block
Green County Wisconsin Barn Quilts

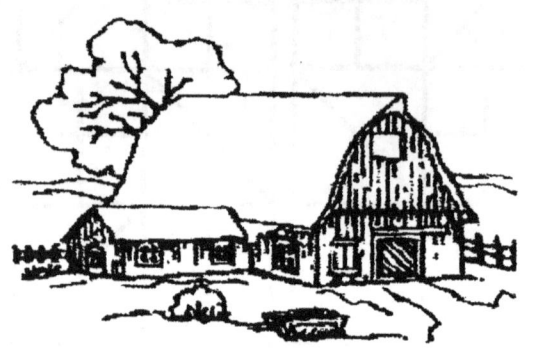

Barn Location
County Road P
Monroe, Wisconsin

Green County Barn Quilt Constellation Block

Barn Quilt Queen's Jewels
Green County Wisconsin Barn Quilts

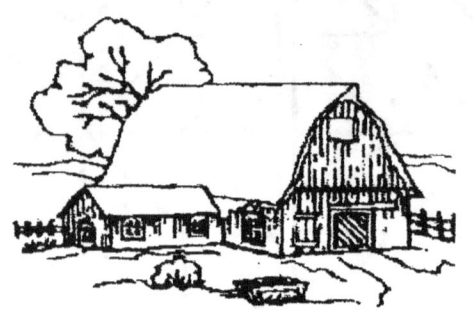

Barn Location
North McDermott Road
Albany, Wisconsin

Green County Barn Quilt Queen's Jewels

Barn Quilt Tumble Weed
Green County Wisconsin Barn Quilts

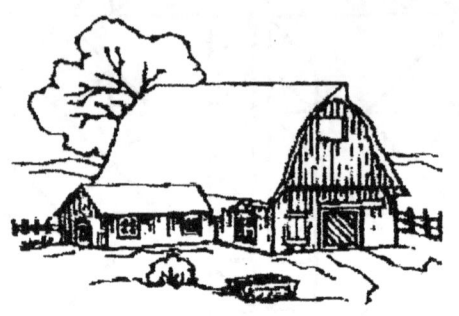

*Barn Location
Hwy 11
Monroe Wisconsin*

Green County Barn Quilt Tumble Weed

Barn Quilt Variable Star
Green County Wisconsin Barn Quilts

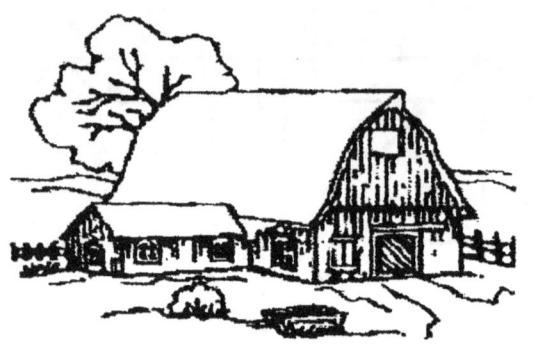

Barn Location
Hwy 11
Monroe, Wisconsin

Green County Barn Quilt Variable Star

Barn Quilt Dove At My Door
Green County Wisconsin Barn Quilts

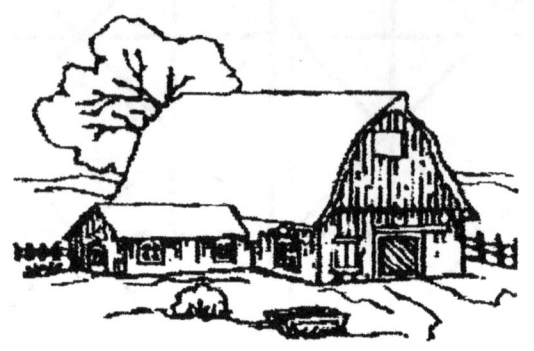

Barn Location
County Rd Y
Monroe, Wisconsin

Green County Barn Quilt Dove At My Door

Barn Quilt LeMoyne
Green County Wisconsin Barn Quilts

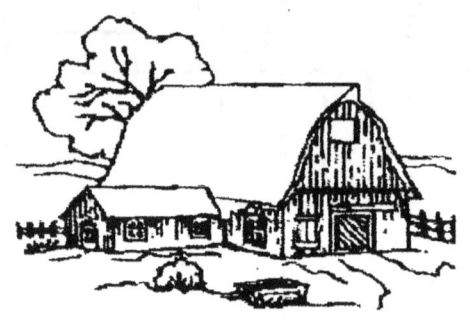

Barn Location
Hwy 69
Monticello, Wisconsin

Green County Barn Quilt LaMoyne

Barn Quilt Churn Dash
Green County Wisconsin Barn Quilts

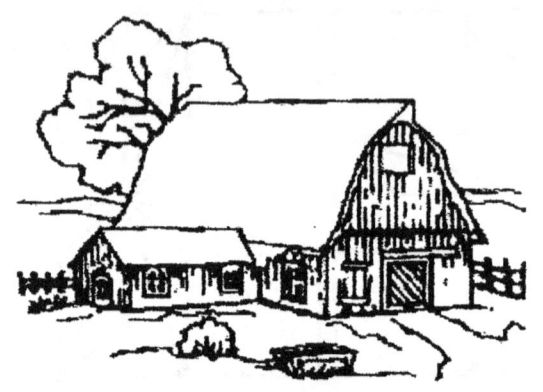

*Barn Location
Sandy Hook Road
Brooklyn, Wisconsin*

Green County Barn Quilt Churn Dash

Barn Quilt Flying Frontier
Green County Wisconsin Barn Quilts

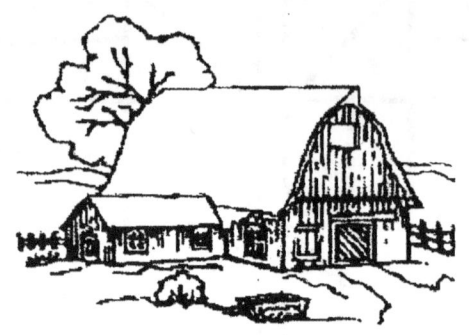

*Barn Location
County Road OK
Brodhead, Wisconsin*

Green County Barn Quilt Flying Frontier

Barn Quilt Valley Star
Green County Wisconsin Barn Quilts

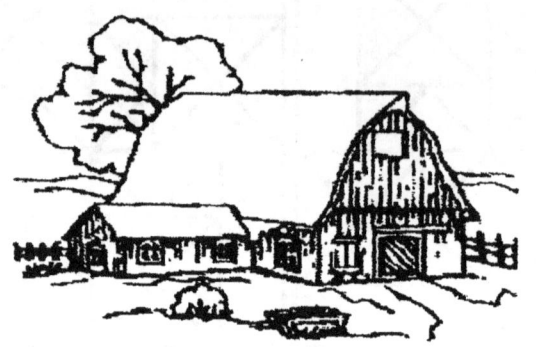

Barn Location
Doughtery Creek Road
Argyle, Wisconsin

Green County Barn Quilt Valley Star

Barn Quilt Dutchman's Puzzle
Green County Wisconsin Barn Quilts

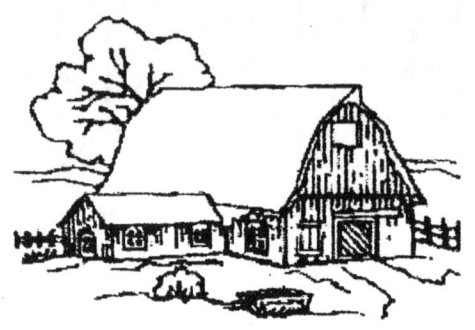

*Barn Location
Franklin Road
Monroe, Wisconsin*

Green County Barn Quilt Dutchman's Puzzle

Barn Quilt Flies In The Barn
Green County Wisconsin Barn Quilts

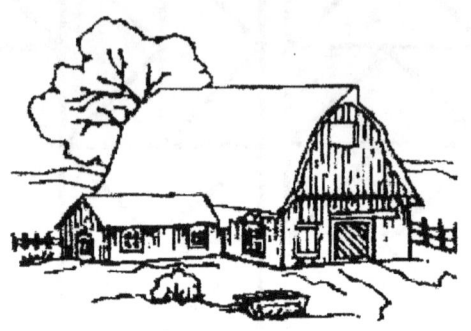

Barn Location
Franklin Road
Monroe , Wisconsin

Green County Barn Quilt Flies in the Barn

Barn Quilt Mom's Den
Green County Wisconsin Barn Quilts

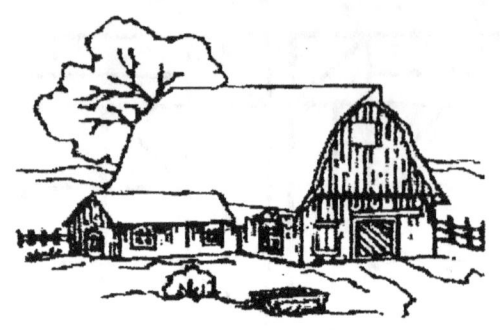

*Barn Location
Grossen Road
Monticello, Wisconsin*

Green County Barn Quilt Mom's Den

Barn Quilt Sunshine in the Valley
Green County Wisconsin Barn Quilts

Barn Location
County Road SS
Monroe, Wisconsin

Green County Barn Quilt Sunshine in the Valley

Barn Quilt Spinning Star
Green County Wisconsin Barn Quilts

*Barn Location
County Road M
Browntown, Wisconsin*

Green County Barn Quilt Spinning Star

Barn Quilt Belted Star
Green County Wisconsin Barn Quilts

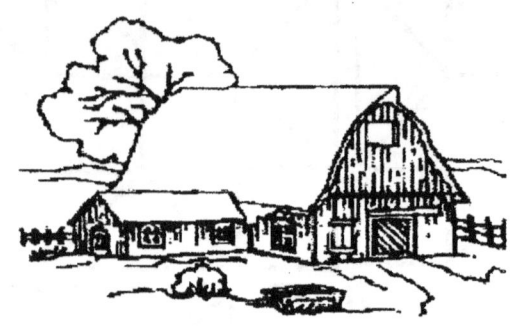

*Barn Location
Brunkow Road
Juda, Wisconsin*

Green County Barn Quilt Belted Star

Barn Quilt Pole Star
Green County Wisconsin Barn Quilts

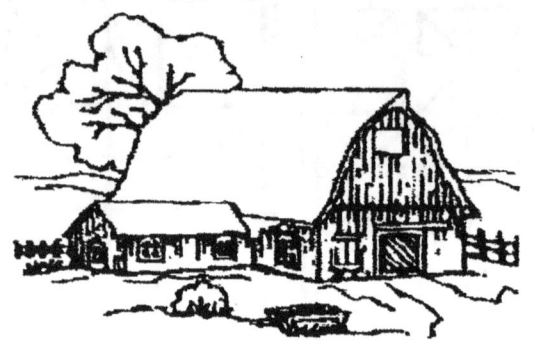

Barn Location
Smock Valley Road
Browntown, Wisconsin

Green County Barn Quilt Pole Star

Barn Quilt Star Puzzle
Green County Wisconsin Barn Quilts

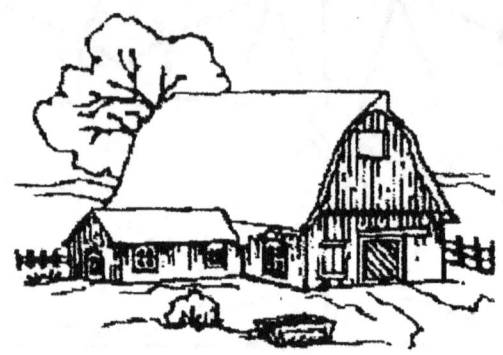

*Barn Location
Hwy 69
Monroe, Wisconsin*

Green County Barn Quilt Star Puzzle

Barn Quilt Marine Star
Green County Wisconsin Barn Quilts

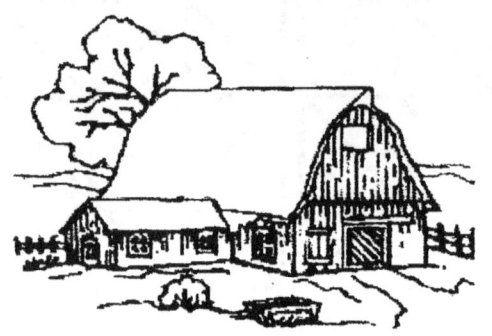

Barn Location
Spring Creek Road
Brodhead, Wisconsin

Green County Barn Quilt Marine Star

Barn Quilt Kayak
Green County Wisconsin Barn Quilts

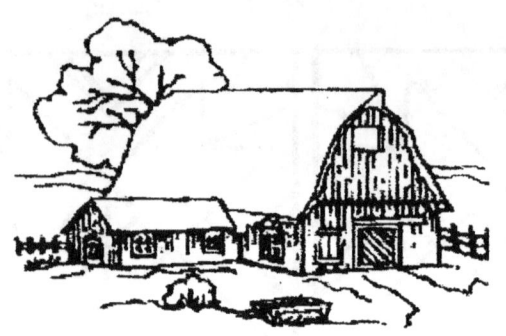

*Barn Location
Bethel Road
Monroe, Wisconsin*

Green County Barn Quilt Kayak

Barn Quilt Little Giant
Green County Wisconsin Barn Quilts

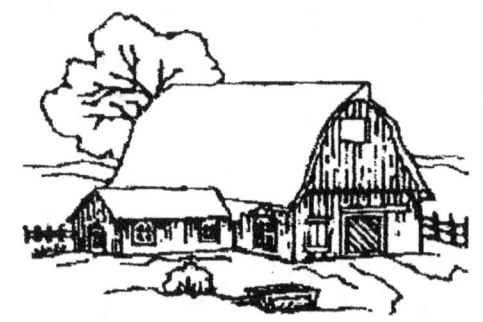

Barn Location
County Road EE
Monticello, Wisconsin

Green County Barn Quilt Little Giant

Barn Quilt Interwoven
Green County Wisconsin Barn Quilts

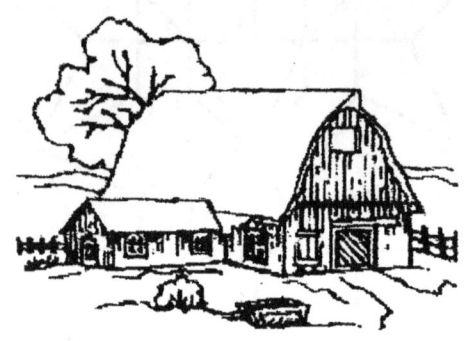

Barn Location
County Road K
Jada, Wisconsin

Green County Barn Quilt Interwoven

Barn Quilt Swiss Star
Green County Wisconsin Barn Quilts

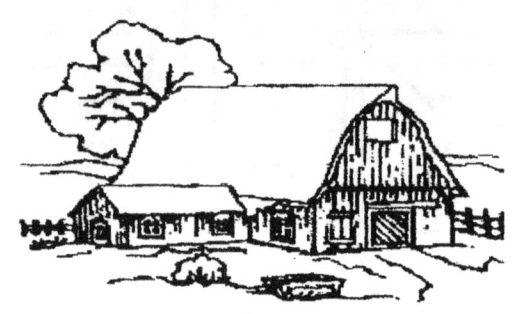

Barn Location
Cold Springs Road
Monroe, Wisconsin

Green County Barn Quilt Swiss Star

Barn Quilt Centennial
Green County Wisconsin Barn Quilts

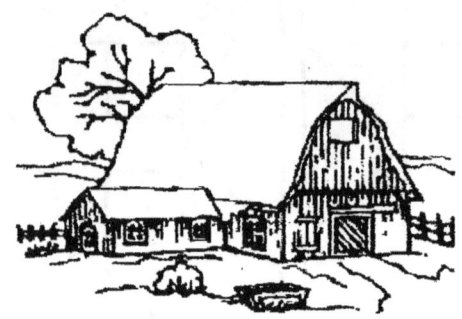

*Barn Location
Joy-Del Road
Monroe, Wisconsin*

Green County Barn Quilt Centennial

Barn Quilt Wisconsin
Green County Wisconsin Barn Quilts

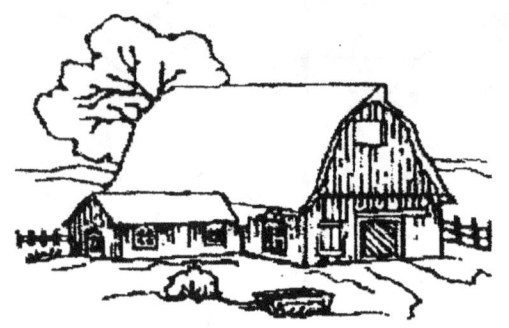

*Barn Location
Bethel Road
Monroe, Wisconsin*

Green County Barn Quilt Wisconsin

Barn Quilt Constellation
Green County Wisconsin Barn Quilts

Barn Location
Stateline Road
Brodhead, Wisconsin

Green County Barn Quilt Constellation

Barn Quilt Cornucopia
Green County Wisconsin Barn Quilts

Barn Location
Ridge Road
Arygle, Wisconsin

Green County Barn Quilt Cornucopia

Barn Quilt Comets
Green County Wisconsin Barn Quilts

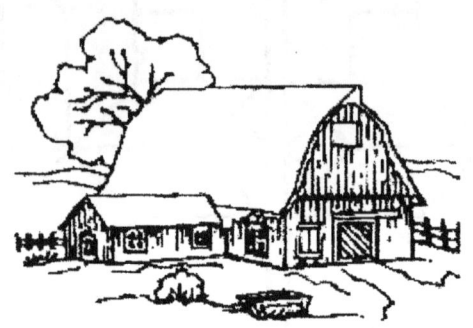

*Barn Location
County Road J
Monroe, Wisconsin*

Green County Barn Quilt Comets

Barn Quilt Corn & Beans
Green County Wisconsin Barn Quilts

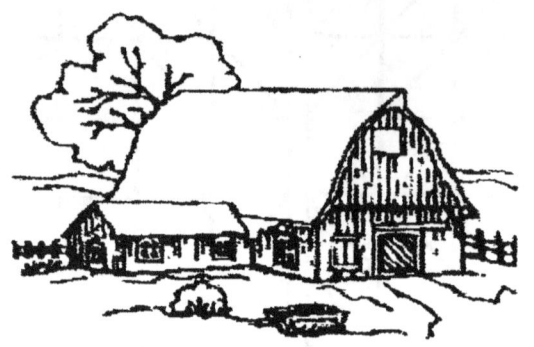

Barn Location
Decatur/Sylvester Road
Monroe, Wisconsin

Green County Barn Quilt Corn & Beans

Barn Quilt Blazing Star
Green County Wisconsin Barn Quilts

Barn Location
County Road KS
Juda, Wisconsin

Green County Barn Quilt Blazing Star

Barn Quilt Hole In The Barn Door
Green County Wisconsin Barn Quilts

*Barn Location
County Road G
Brodhead, Wisconsin*

Green County Barn Quilt Hole In The Barn Door

Barn Quilt Grandpa's Delight
Green County Wisconsin Barn Quilts

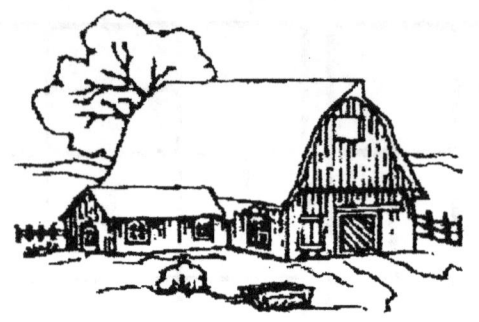

*Barn Location
County Road C
Monticello, Wisconsin*

Green County Barn Quilt Grandpa's Delight

Barn Quilt Rolling Star
Green County Wisconsin Barn Quilts

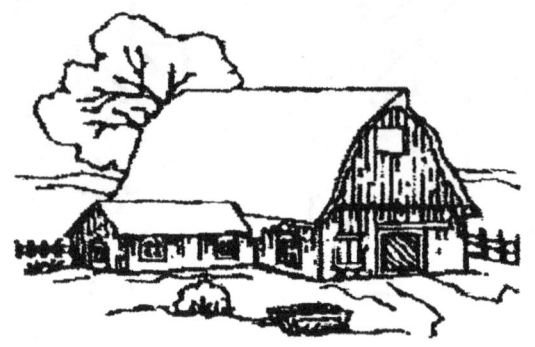

Barn Location
Shanghai Road
Juda, Wisconsin

Green County Barn Quilt Rolling Star

Barn Quilt Union Star
Green County Wisconsin Barn Quilts

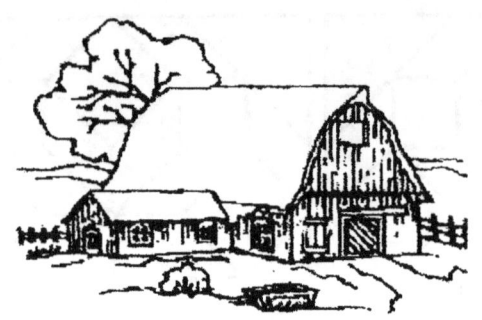

Barn Location
Yankee Hollow Road
Blanchardville, Wisconsin

Green County Barn Quilt Union Star

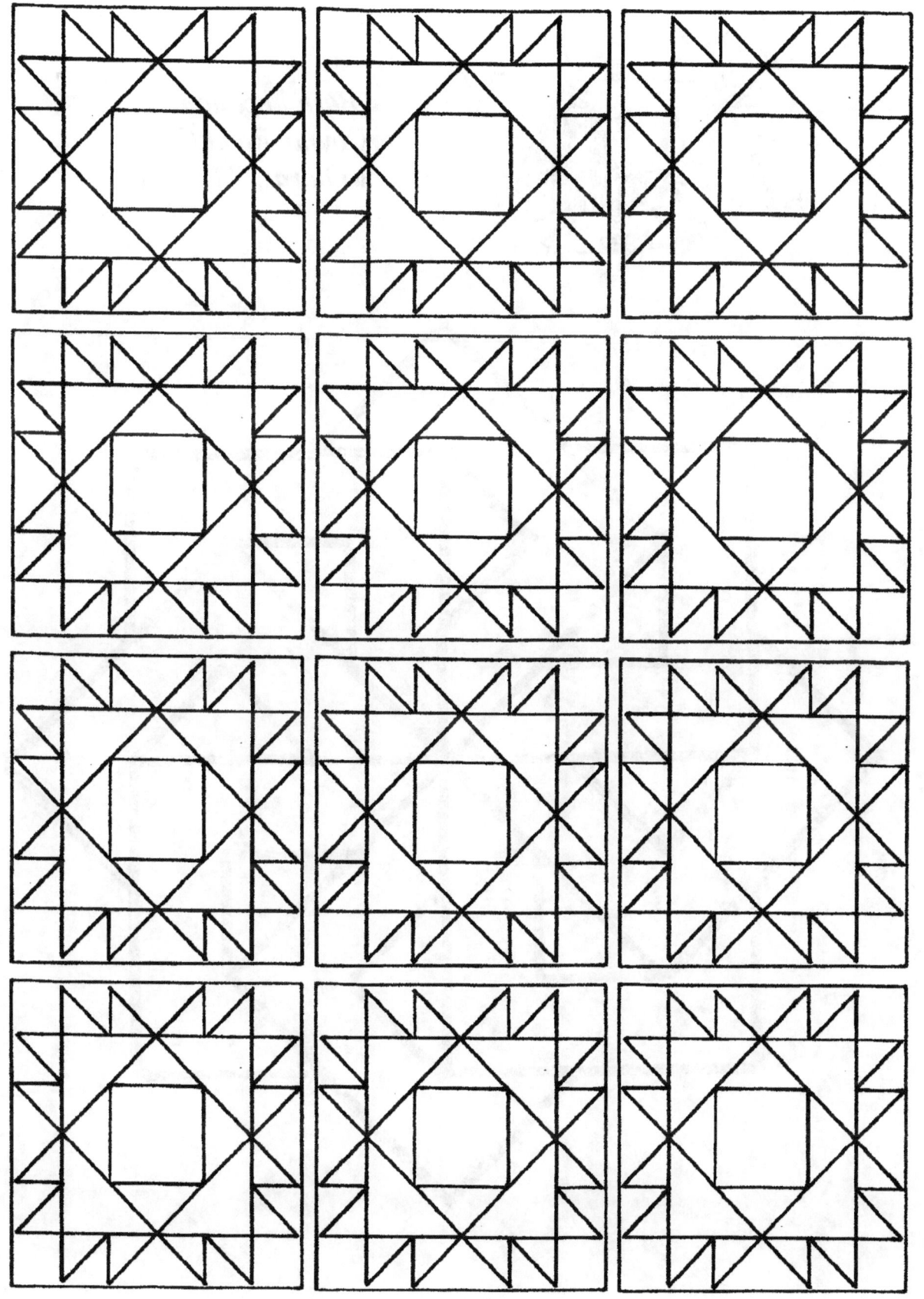

Barn Quilt Star Spin
Green County Wisconsin Barn Quilts

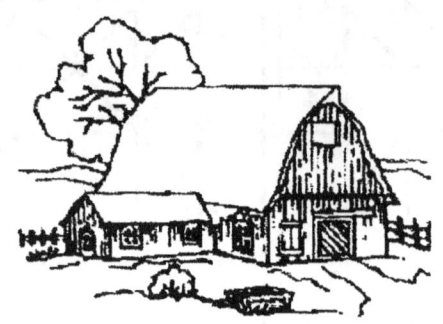

*Barn Location
County Road H
New Glarus, Wisconsin*

Green County Barn Quilt Star Spin

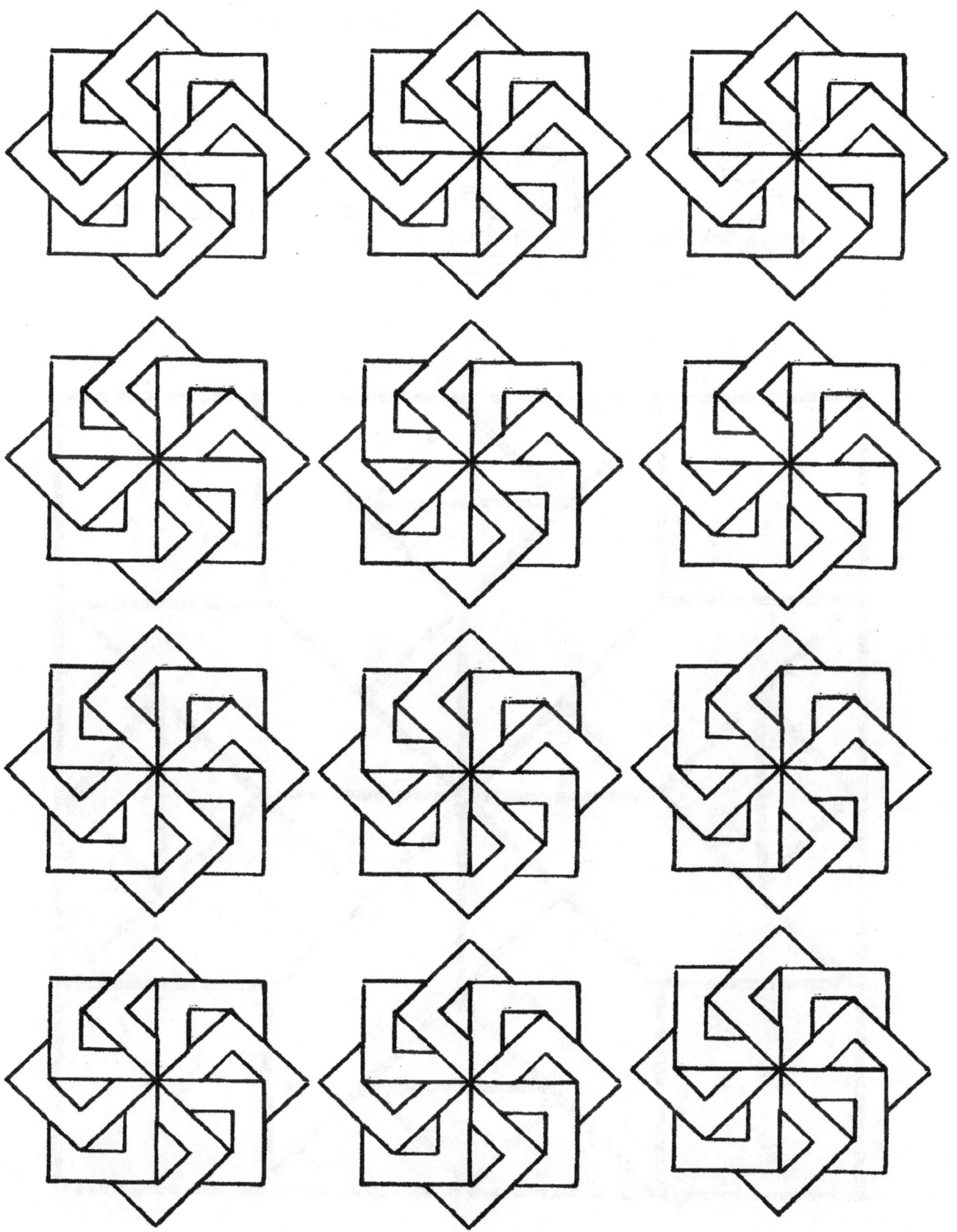

Barn Quilt Dividing Ridge Star
Green County Wisconsin Barn Quilts

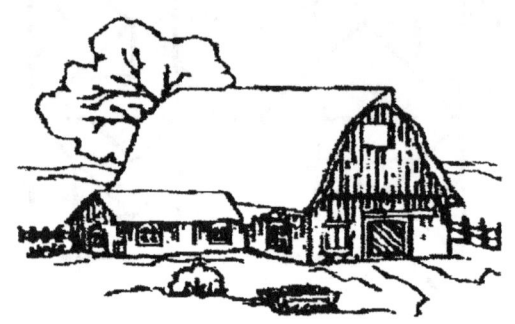

Barn Location
Dividing Ridge Road
Monticello, Wisconsin

Green County Barn Quilt Dividing Ridge Star

Barn Quilt Grandmother's Pride
Green County Wisconsin Barn Quilts

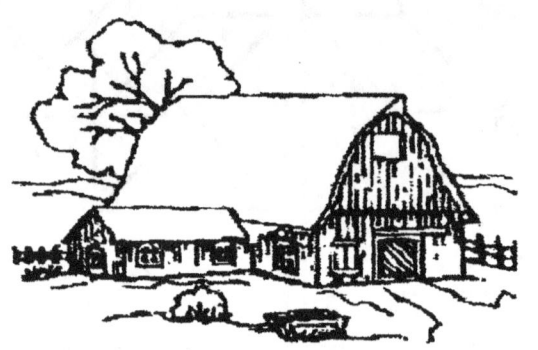

Barn Location
Brunkow Road
Juda, Wisconsin

Green County Barn Quilt Grandmother's Pride

Barn Quilt Farmer's Daughter
Green County Wisconsin Barn Quilts

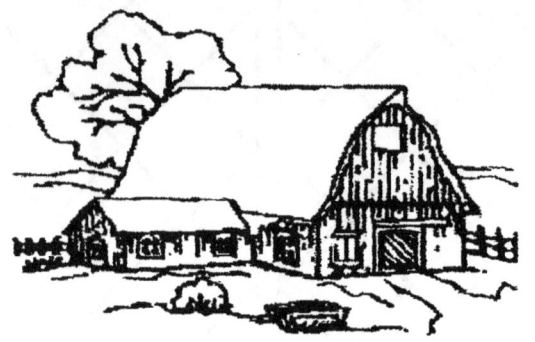

Barn Location
Five Corners Road
Monroe, Wisconsin

Green County Barn Quilt Farmer's Daughter

Barn Quilt Evergreen
Green County Wisconsin Barn Quilts

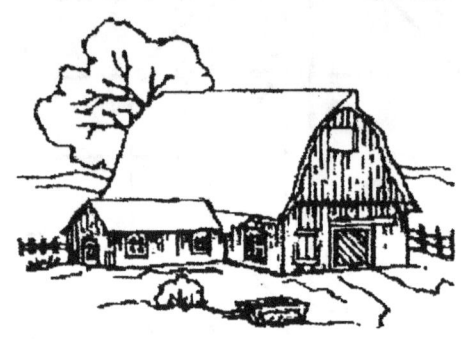

Barn Location
Middle Juda Road
Juda, Wisconsin

Green County Barn Quilt Evergreen

John Lettau Coloring Books

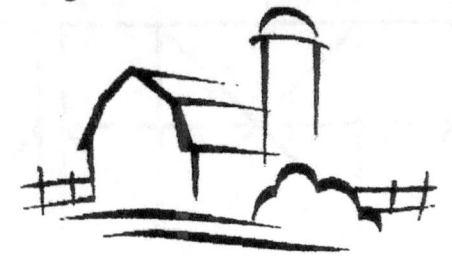

Barn Quilt Coloring Books

Shawano County Wisconsin Barn Quilt Coloring Book One
Shawano County Wisconsin Barn Quilt Coloring Book Two
Green County Wisconsin Barn Quilt Coloring Book
Delaware County Iowa Barn Quilt Coloring Book
Tennessee Appalachian Barn Quilt Trail Coloring Book One
Tennessee Appalachian Barn Quilt Trail Coloring Book Two
Franklin County Vermont Barn Quilt Coloring Book

Geometric Patterns

Geometric Design Coloring Book 1
Geometric Design Coloring Book 2
Geometric Design Coloring Book 3
Geometric Design Coloring Book 4
Geometric Design Coloring Book 5

Graph Paper Designs

Create Geometric Quilt Designs with Graph Paper Designs

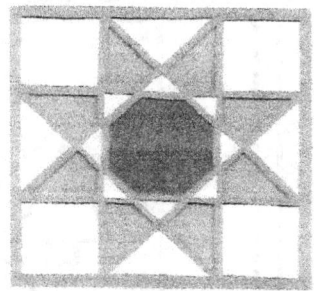 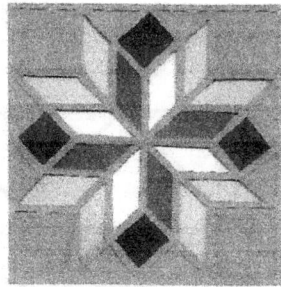 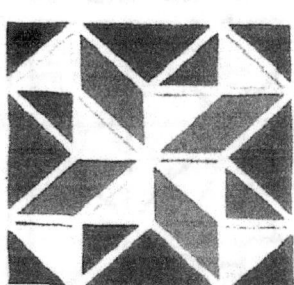

Coloring Relieves Stress and Tension
Order...John H. Lettau at Amazon.com

READING & MATH BOOKS by JOHN H. LETTAU

1st Dimension	Grades 3-6
2nd Dimension	Grades 3-6
Primary Dimension	Grades 1-4
Aztec Math Primary Book One	Grades 1-3
Aztec Math Primary Book Two	Grades 1-3
Aztec Math Intermediate Book One	Grades 3-6
Aztec Math Intermediate Book Two	Grades 3-6
Aztec Math Jr. High Book One	Grades 5-8
Aztec Math Jr. High Book Two	Grades 5-8
Aztec Math Decimal Book	Grades 4-8
Aztec Math Fraction Book	Grades 4-8
Sum-Action Number Puzzle Book One	Grades 3-6
Sum-Action Number Puzzle Book Two	Grades 3-6
Sum-Action Number Puzzle Primary Book One	Grades 1-3
Sum-Action Number Puzzle Primary Book Two	Grades 1-3
Multiplication Number Puzzles	Grades 3-6
Geometric Design Puzzle Book One	Grades 3-6
Geometric Design Puzzle Book Two	Grades 3-6
Aztec Reading Primary Book One	Grades 1-3
Aztec Reading Primary Book Two	Grades 1-3
Math in Action	Grades 3-6
A-Maze-ing Number Puzzles	Grades 3-6
Graph Paper Designs	Grades 2-6
Pick-A-Dilly Papers	Grades 3-6
Awards for All Reasons	Grades 1-6
Time Marches On	Grades 1-3
Pennies, Nickels & Dimes	Grades 1-3
Super-Sum Activity Cards	Grades 3-6
Learning Center Game Boards	Grades 1-3
Aztec Design Coloring Book	Grades 1-6

www.ingramcontent.com/pod-product-compliance
Lightning Source LLC
Chambersburg PA
CBHW080708190526
45169CB00006B/2295